W9-BYA-960

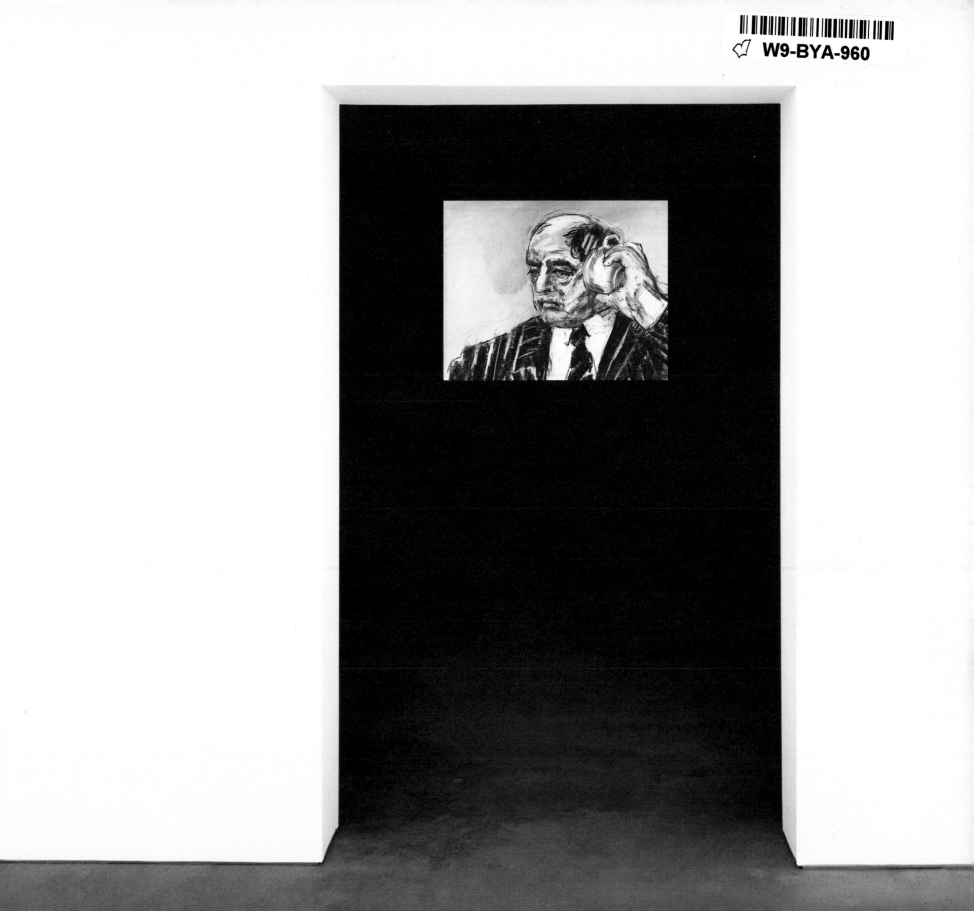

This publication was prepared in conjunction with the exhibition
William Kentridge: WEIGHING...and WANTING. Curated by Hugh M.
Davies, it was presented at the Museum of Contemporary Art, San
Diego from January 25 through April 12, 1998. The exhibition and
catalogue are made possible, in part, by a contribution from Michael
and Brenda Sandler, and a grant from the National Endowment for
the Arts, a federal agency.

© 2000 Museum of Contemporary Art, San Diego
All rights reserved. No part of the contents of this book may be
published without the written permission of the
Museum of Contemporary Art, San Diego
700 Prospect Street
La Jolla, California 92037-4291
(858) 454-3541 www.mcasandiego.org

Publication coordinated by Andrea Hales

Designed by Burritt Design, San Diego

Edited by Julie Dunn

Printed and bound in the United States by Precision Litho, Vista,
California

Photography: Pablo Mason
© W. Kentridge 1997

Library of Congress Catalogue Card Number 00-109366
ISBN 0-934418-58-6

Frontispiece: William Kentridge, installation detail of *WEIGHING...and
WANTING*, Museum of Contemporary Art, San Diego, 1998.

Available through D.A.P./Distributed Art Publishers
155 Sixth Avenue, 2nd Floor
New York, NY 10013
Tel: (212) 627-1999 Fax: (212) 627-9484

WILLIAM KENTRIDGE

WEIGHING...
and WANTING

IT was a great honor for the Museum of Contemporary Art, San Diego to be the first museum in the United States to present, in 1998, an exhibition of William Kentridge's work. I was born in South Africa (although I left at an early age) and, perhaps for that reason, have always had a special interest in seeing that nation, despite its decades of civil strife, take its place in the international art world. With the end of apartheid—beginning with the release of the imprisoned Nelson Mandela in 1990 and leading to the first democratic elections in 1994—new possibilities began to open up for the South African artist community.

I first saw Kentridge's work in *The New York Times Magazine* in the early 1990s and, after viewing one of his films at Ruth Bloom Gallery in Santa Monica, was convinced that his was a talent of the highest order. I subsequently invited William to come and do a residency in San Diego, followed by an exhibition. We struggled for more than a year to find dates that would allow him to bring his family but unfortunately had to abandon that plan. However, we were delighted to have William here for the month of January 1998.

The entire experience—artist's residency, exhibition, and the later acquisition of twelve drawings from *WEIGHING...and WANTING*, as well as the film installation, for the MCA collection—has been extremely meaningful for me, even more so when the Museum Trustees surprised me by acquiring the installation in honor of two personal milestones: my fiftieth birthday and my fifteenth year as MCA's director.

Our exhibition, *WEIGHING...and WANTING*, traveled to seven venues in North America following its premiere in San Diego, and I would like to thank the following institutions who were eager to support Kentridge's work: the North Dakota Museum of Art, Grand Forks, North Dakota; the MIT List Visual Arts Center, Cambridge, Massachusetts; the Forum for Contemporary Art, St. Louis, Missouri; the Salina Art Center, Salina, Kansas; the Art Gallery of Ontario, Toronto, Canada; the University of Michigan Museum of Art, Ann Arbor, Michigan; and Bowdoin College Museum of Art, Brunswick, Maine.

This exhibition would not have been possible without the generous sponsorship of Brenda and Michael Sandler—two passionate collectors who also allowed us to borrow several of their Kentridge drawings. We are also grateful to the National Endowment for the Arts, the federal agency that has been responsible for so many of MCA's exhibitions, catalogues, and programs over the years. It was a pleasure working with William Kentridge's South African representative, Goodman Gallery, as well as his private dealer, David Krut, and we are grateful for their help. We offer particular thanks

to the distinguished art writer Leah Ollman for her insightful and sensitive understanding of Kentridge's work, and to designer Richard Burritt and editor Julie Dunn for their fine efforts on this publication. As always, I am grateful to the MCA staff for their many contributions, but I would like to offer special thanks to Andrea Hales, Mary Johnson, Anne Farrell, Elizabeth Armstrong, Charles Castle, Lynda Forsha, former librarian Virginia Abblitt, and former curatorial intern Rita Gonzalcz.

Most of all, I am indebted to the artist himself. His vision is eloquently expressed, thought-provoking and profoundly moving, and it is our sincere hope that this catalogue will do his powerful art at least a measure of justice.

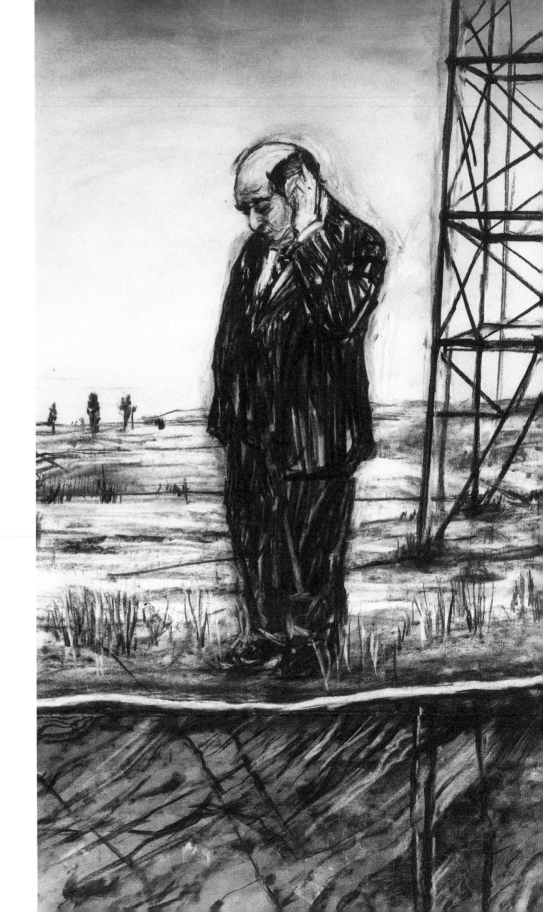

IN the fifth chapter of the Book of Daniel, the Babylonian king Belshazzar has a vision. He is in the middle of hosting a great feast, his mind slicked by wine, when he sees a hand, unattached, writing on the plaster of the palace wall. *Numbered, weighed, divided*, reads the inscription. Only Belshazzar can see the words, but he can make no sense of them. All of his sages try to decipher the message to no avail, until finally the queen summons Daniel, a Jewish exile with proven gifts for interpreting dreams and loosing enigmas. Daniel relays the sobering message—a rebuke of the king for not having assimilated the lesson of his arrogant predecessor, Nebuchadnezzar, who learned too late that God has sovereignty over even the most powerful earthly ruler. Neither have you humbled yourself before God, Daniel tells the proud Belshazzar. *Mene*: God has numbered the days of your kingdom, and brought it to an end. *Tekel*: You have been weighed in the scales and found wanting. *Parsin*: Your kingdom has been divided and given to the Medes and Persians. That night, as the legend goes, Belshazzar was killed, and his kingdom turned over to another.

Several years ago, William Kentridge dreamed an image of writing on a wall. Ever receptive to notions that start "in the alleys and sluices of the mind," Kentridge embraced the vision, pursued it, assumed responsibility for it, abided by its consequences. Unlike the disarming vision of Belshazzar, Kentridge's gave him comfort, and *WEIGHING...and WANTING* (1998), the animated film generated by the dream, begins with an image of comfort—a cup, whose contents raise a faint flag of steam, a delicate banner of domesticity and the reassurance of routine. But within moments, that stability is undone by the intimation of disease, as Kentridge shows a man sliding into an MRI chamber. Scales, with nothing on them, rise and fall, tip, then tip the other way. Things get worse before they get better. The man's relationship suffers a cataclysm, the cup gets shattered, and the drawn images that comprise the fabric of the film are torn and scattered. When balance does come, in the end—the cup restored to wholeness, the images fused together—it's a tentative, tenuous balance. The best, perhaps, that can be hoped for.

WEIGHING...and WANTING was born by a dream. Other "drawings for projection" that Kentridge has made over the past dozen years launched from phrases, anagrams, images that beckoned to be chased. His process of filming a drawing's evolution through additions, alterations and erasures, his drawing on the wall, is his way of loosing the enigma of those initial prompts. Happenstance and reason coalesce to propel the films forward. Episodic and image-driven, the films have the texture of a rough draft, a diary, reflect-

ing the concerns, both petty and profound, of the moment. "Units of impression," as the filmmaker Eisenstein called them, strung together in a chain of associations, totalling notes toward an understanding of the unfinished.

The diarist shapes the tale as he goes—confessing, witnessing, speculating, fantasizing, pining, mourning. Clearly, he cannot know how the story will end. It simply persists. Like the characters in them, Kentridge's films tumble through time on the momentum of associations, loves, fears and memories. Each frame, each entry, another opportunity to reckon with the self, its internal conflicts and contradictions, its yearnings for comfort.

The two central characters in Kentridge's films, wealthy Johannesburg mine-owner Soho Eckstein and the pensive observer Felix Teitlebaum, reveal themselves, sometimes surprisingly, over the course of the films. Their identities are defined cumulatively rather than categorically, and their emergence suggests the nuanced demands of the novel more than the easy legibility of caricature. Soho, introduced in the first film (*Johannesburg, 2nd Greatest City after Paris*, 1989) as a burly, craggy-faced oppressor, is, for all of his ruthlessness and greed, lonely and doubt-ridden. Felix, naked and painfully vulnerable, nevertheless takes advantage of the opportunity (in the same film and later in *Sobriety, Obesity & Growing Old*, 1991) to carry on an affair with Soho's wife. From film to film, Soho and Felix move in and out of psychic equilibrium. Neither has a monopoly on our empathy; neither can be dismissed as wholly alien in action or instinct. Rather than mutually exclusive types, they embody complementary impulses coexisting within each of us. That tentative, tenuous state of balance reached at the end of *WEIGHING...and WANTING* is a counterpart to, or maybe a consequence of the fragmented, fluid nature of individual identity—the condition of the self, in J.M. Coetzee's words, as "multiple and multiply divided against itself."

In *WEIGHING...and WANTING*, the sole male character is a composite—Felix's susceptibility clothed in Soho's authoritative physical form. He wears Soho's signature pinstriped suit, but lacks the aggression that the uniform has come to signify in the previous films. Instead, he is lonely, introspective, projecting a palpable aura of loss. He holds the teacup to his ear like a seashell, listening for larger rhythms that might restore his balance.

At the film's beginning, he wanders the arid land around his house (a striking modernist design much like those Kentridge remembers from his childhood neighborhood in Johannesburg) and his gaze fastens upon a large stone, which he brings indoors, turning it over in his hands as if searching for clues to his own isolation. The rock's surface, like the man's expressionless face, yields little, but in the cascade of images that ensues, the stratification of the rock is likened to the layers of human memory, and both are duly excavated.

Images of the stone marked with precise red striations give way to cross-sections of the brain, images that vacillate between abstract mappings made by a high-tech scanner and window-like views onto scenes from the man's life. Again, memories of comfort come first— the man's head resting in the woman's lap, their embrace, his fingers gently stroking her bare skin. The score quickens and intensifies as their domestic tranquility erodes, erupting into violence. Tall pylons rise with a clatter and replace the figure of the standing woman. Struts of the pylons seem to slash the man's back. There is a brief caesura in which a message appears to the man, spelled out by the pylon's struts. *In whose lap do I lie* reads his call to self-judgment. To whom, the words glare at him, is he beholden? To whom is he faithful? Where does he seek shelter, comfort?

The film is an exquisite visual poem, a viscerally wrenching collaboration of imagery and sound, whose discontinuous narrative fluctuates between outer landscape and inner. Shape-shifting trans-

mutations and cross-identifications pepper the film, intensifying its stream-of-consciousness veracity and pungency. When the relationship between the man and woman dissolves, Kentridge erases her, and the man's head no longer rests in the soothing cradle of her lap but atop a bulky, old-fashioned telephone, a crude vehicle for communion compared to skin-against-skin. Finally, the telephone transforms into a black cat, an affectionate surrogate whose uncritical presence only underscores the depth of the man's loss. In the end, after man and woman seem to have humbled themselves enough to forge a tender reconciliation, the man closes his eyes in peace, outside, his head resting on the stone.

WEIGHING...and WANTING is, by the artist's own admission, the most personal of his films. Except for the brief appearance of mine workers in the distance, the cast of characters numbers only two, and the settings are limited to private spaces—the home, its immediate surrounds, and the claustrophobic intimacy of the MRI chamber. But when played out on the tremulous fault zone of South Africa's brutal recent history, even such a domestic, interpersonal drama gathers political steam. Since rejecting the mandate of apartheid in the country's first free elections in 1994, and enduring the searing testimonies of victims and perpetrators during hearings of the Truth and Reconciliation Commission, South Africans have had to address memory—embedded in the land no less than the body—as a palpable force to be reckoned with. How much to hold onto the past as a way of navigating the future, and how much to let go or suppress it as an impediment to progress? At what price reconciliation? The writing burns right through the wall.

Kentridge initially traced Soho's lineage to the corrupt cast of characters in George Grosz's prints and drawings indicting the Weimar bourgeoisie. He puffs on a cigar through most of the films and wears his pinstriped suit like protective armor, whether at his desk, in bed, or comatose in the hospital. After the character took shape, Kentridge then recognized Soho's similarity to a photograph of his own paternal grandfather, a lawyer, sitting on the beach fully dressed, resembling an older version of the artist himself. Soho began to feel closer to home at that point, and started to converge with the character of Felix. The characters meld to become a single protagonist in *WEIGHING...and WANTING*, and in Kentridge's subsequent film, *Stereoscope* (1999), the man's duality literally splits the screen, and the narrative proceeds along two concurrent lines, bifurcated and conflicted as the man's own conscience.

With stark brevity, Kentridge's drawings for projection chronicle struggles for self-definition and self-preservation within the highly-charged contexts of both home and country. They register a perpetual battle against passivity, selfishness and greed. By encouraging identification, at different times, with the disparate impulses of the character/s, Kentridge whittles away at the triad of mutually exclusive roles—perpetrator, victim, and bystander—that comprise the standard scenario for injustice. His work proposes a model both more flexible and more demanding, allowing (or simply accepting as inevitable) the possibility of occupying multiple positions along a single continuum.

Fluidity is the operative force here—a formal sense of flux that mimics the mechanics of thought. Drawing, Kentridge has said, embodies doubt. Drawings that move and metamorphose, as in his animated films, resist the false authority of fixity even more strongly to bear instead the real, experiential weight of indeterminacy. Boundaries between the felt and the imagined, the seen, remembered and desired, the dreamed and the transcribed, are entirely permeable in Kentridge's films, as in the fluid, dream-driven films we live every day. When Soho looks at a framed photograph of his wife on his office desk (in *Sobriety...*) and the picture refuses to be still, to reflect her fixed, ideal image, but is instead in motion, revealing

the range of her betrayals and graphically illustrating Soho's own fears, the scene reads as extraordinary, a breach of expectation. Yet that phenomenon, that layering and simultaneity, happens daily as a matter of course in our private worlds. What is extraordinary is Kentridge's ability to render that experience so convincingly and affectingly, by casting the material props of existence and its more evanescent threads as equally contingent.

Self and other, past and present—where to draw the dividing lines? Kentridge spends as much energy erasing borders as erecting them. But as resistant as he is to closure and fixity, he is equally troubled by letting go, by the erosive power of forgetting and the more strategic act of "disremembering." His films conjure the physical texture of memory but also its moral dimensions, the discontinuities it provokes, the burden of its light—or shadow. His continual erasures yield ghosts, traces, stains, evoking memory's natural slippage as well as a less benign, more calculated form of amnesia. Both have conspired to distance a childhood memory of his own, of the day he happened upon photographs of victims of the 1960 Sharpeville Massacre on the desk of his father, who served as counsel for the victims' families. The shock of that discovery has been blunted by time and the necessity of carrying on, but Kentridge contin-

ually strives for its return. His drawings act as an urgent summons.

Kentridge's imagery churns in the mind, a catalyst of self-definition for the viewer no less than for the artist. His portraits, to paraphrase the poet and painter Breyten Breytenbach, are not only inevitably self-portraits but also ancestors, as much Kentridge's maker as he is theirs. Such fluidity between maker and made is pivotal to Kentridge's work. After all, he is not only the dreamer who gives rise to the images in *WEIGHING...and WANTING*, but also the one who inscribes his visions on the wall, as well as the one who mines them for meaning. Stub of charcoal in hand, he brings his visions forward to that point of tentative, tenuous balance. There the marks stay, rich, raw and perpetually unfinished, ready to slip into the alleys and sluices of another mind.

28 June 2000

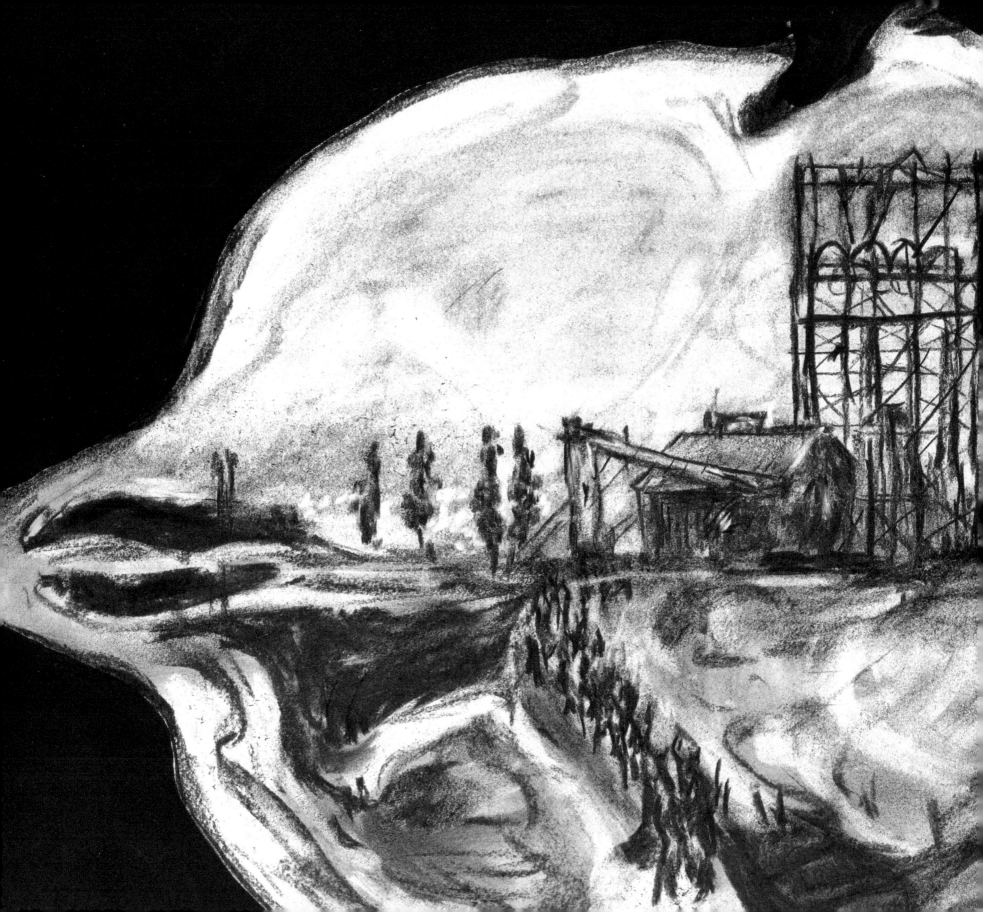

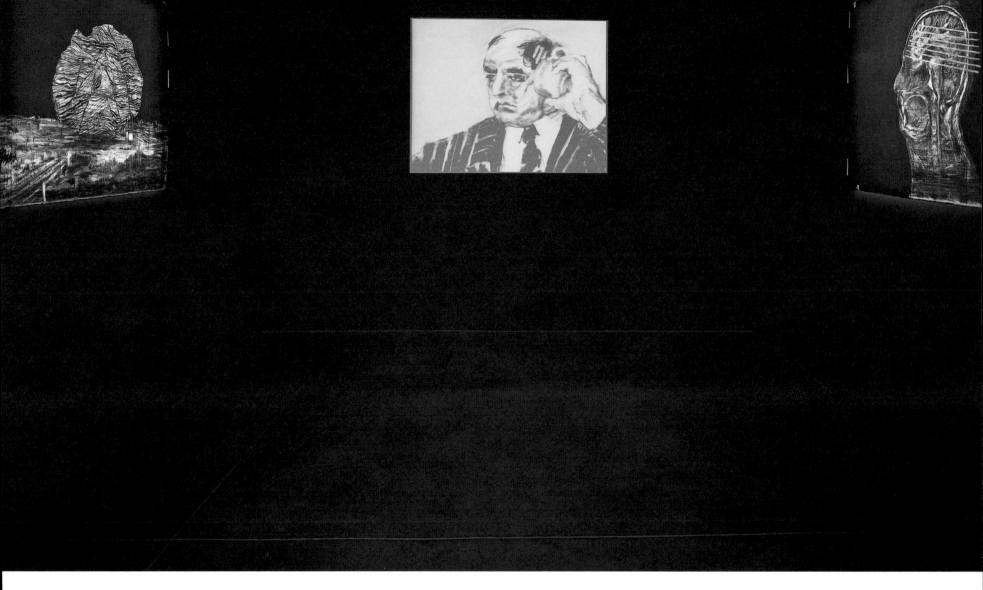

William Kentridge makes drawings that he erases, alters or adds elements to, then progressively films them, thereby bringing the drawings to life. At the 1998 Museum of Contemporary Art, San Diego exhibition, Kentridge's six-minute film, *WEIGHING...and WANTING*, was, for the first time, shown together with his working drawings.

The core of the exhibition was a darkened viewing room designed by the artist measuring 19 feet deep by 14 1/2 feet wide. The film was projected on one wall, with two large-scale drawings installed on either side of the film. With a drawing either projected or on paper installed on each wall, the viewer was able to enter into Kentridge's dreamlike, poetic world.

Surrounding the exterior of the viewing room in the Copley Gallery at MCA's Downtown location were twenty drawings and eighteen drawing fragments that the artist used to make his film.

WEIGHING...
and WANTING

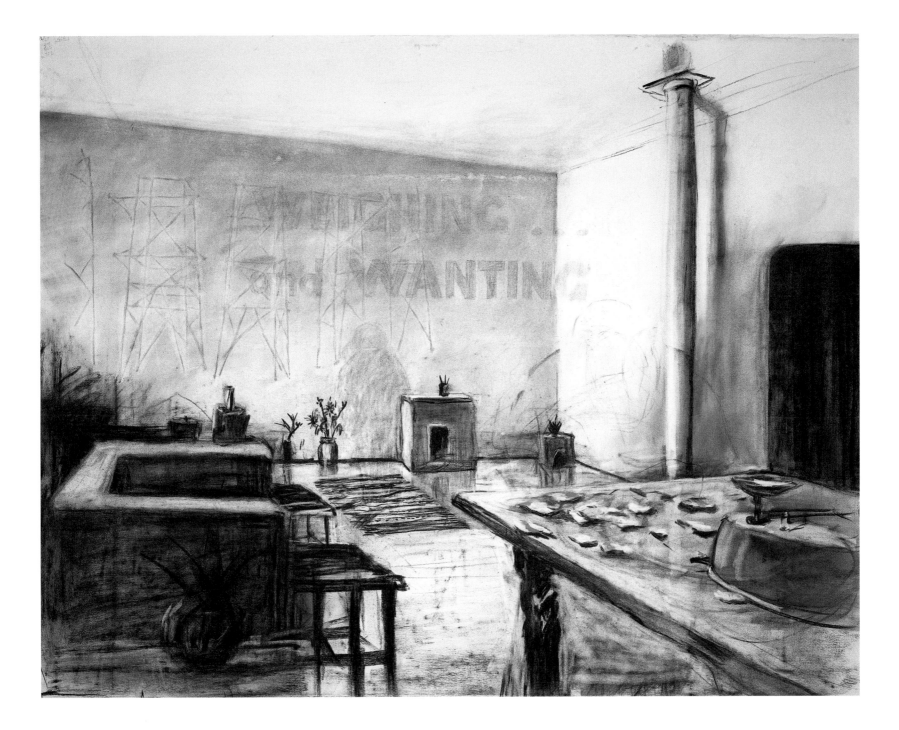

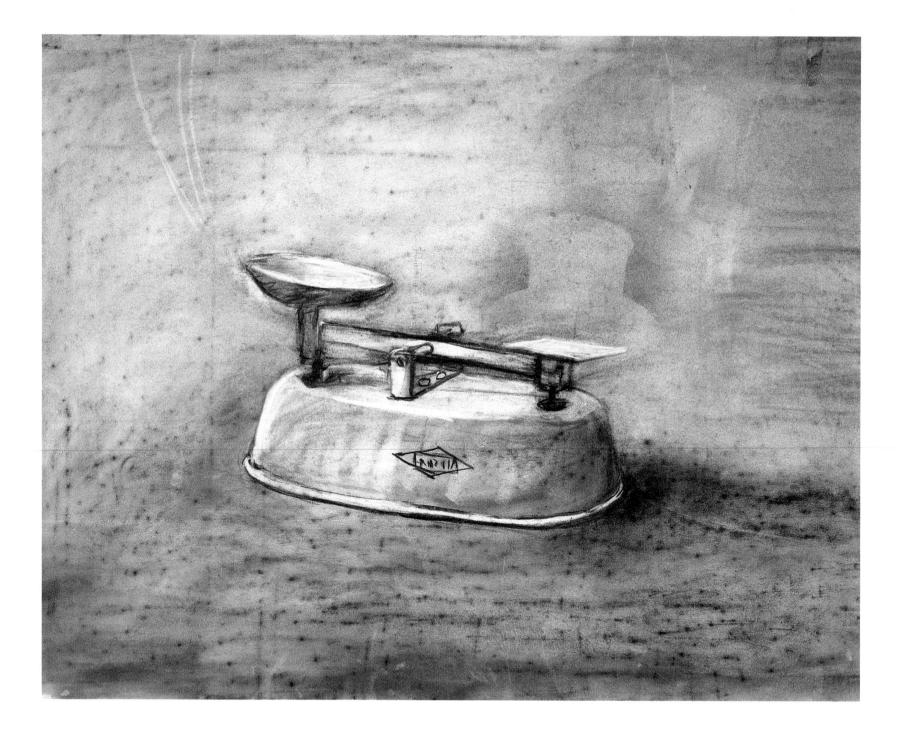

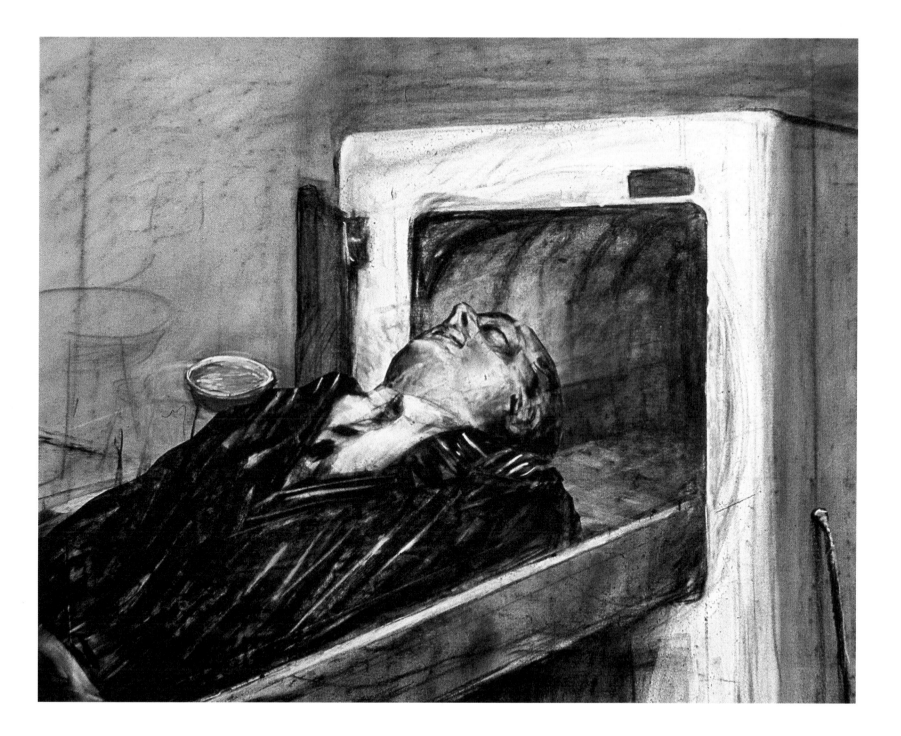

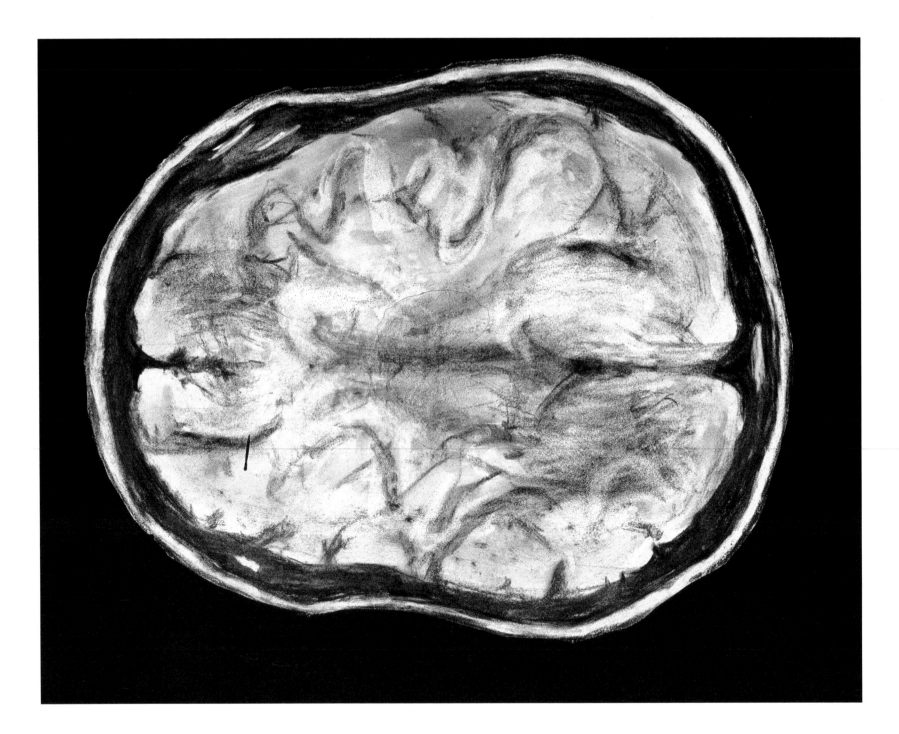

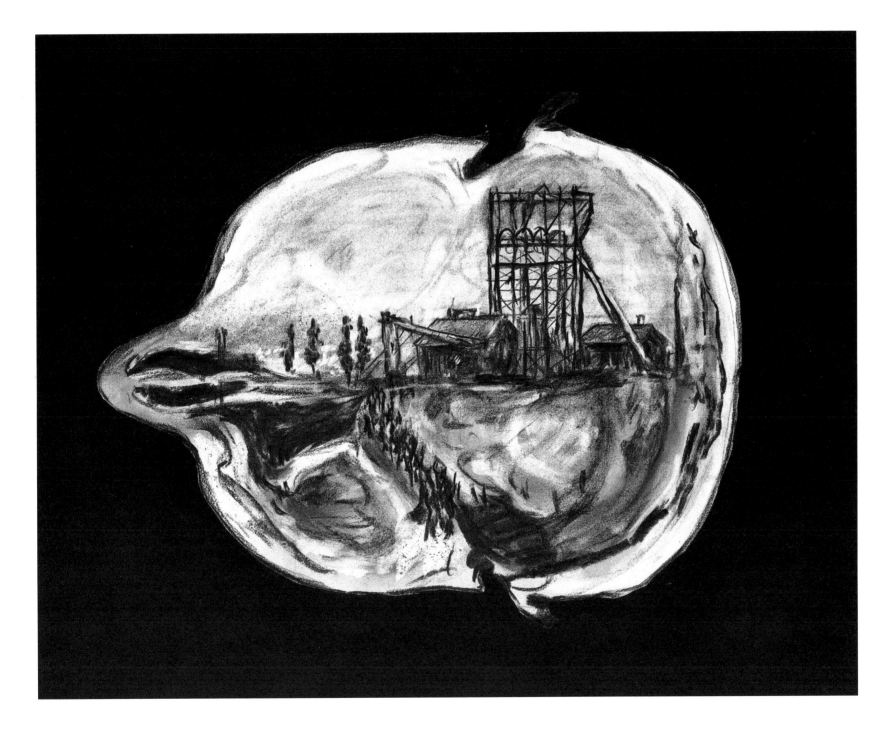

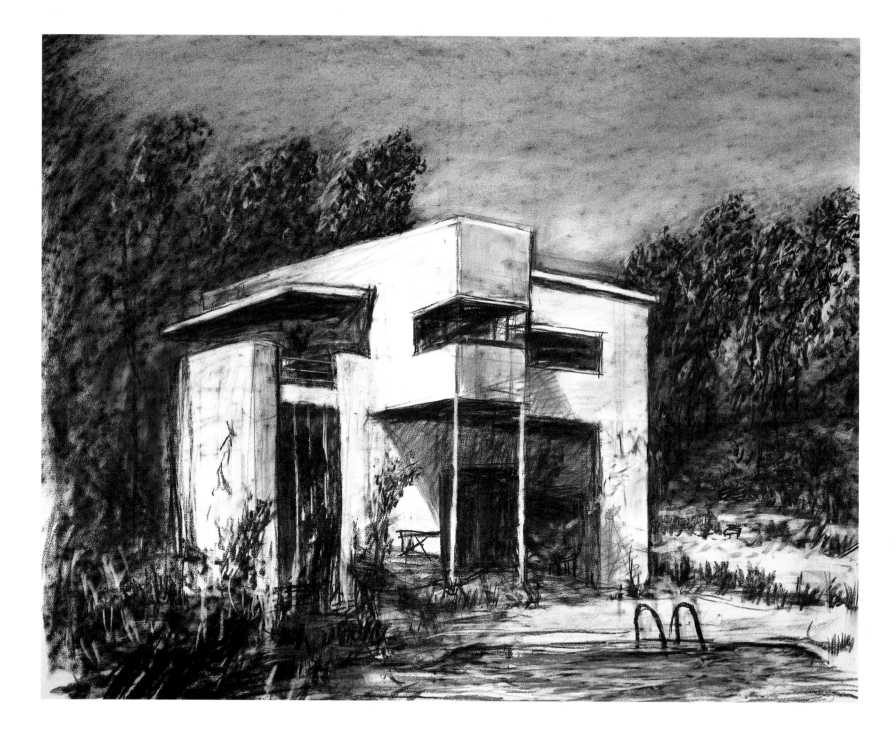

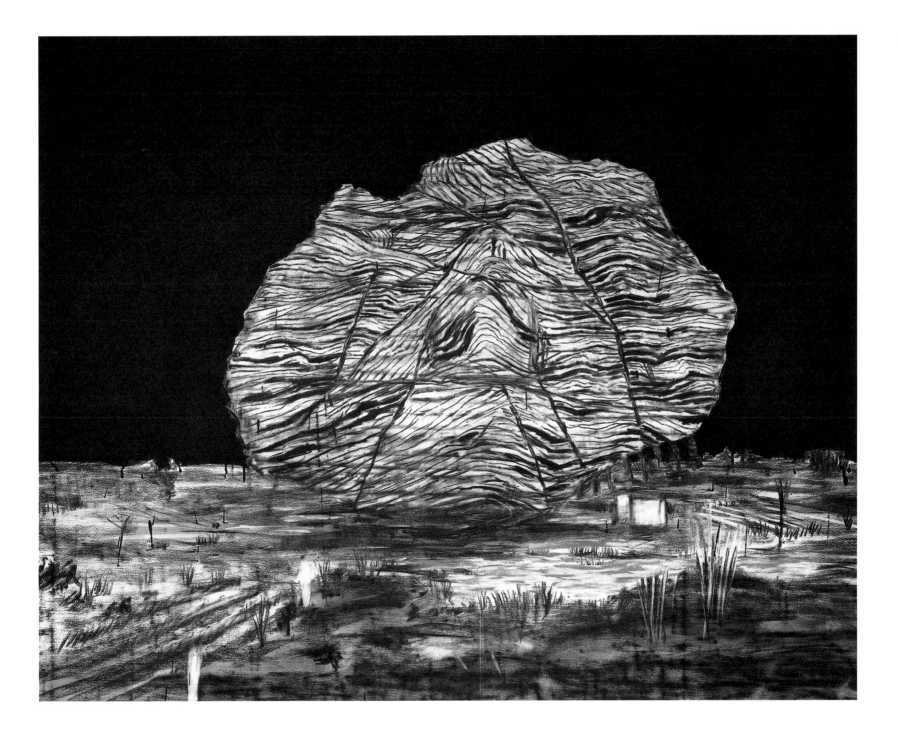

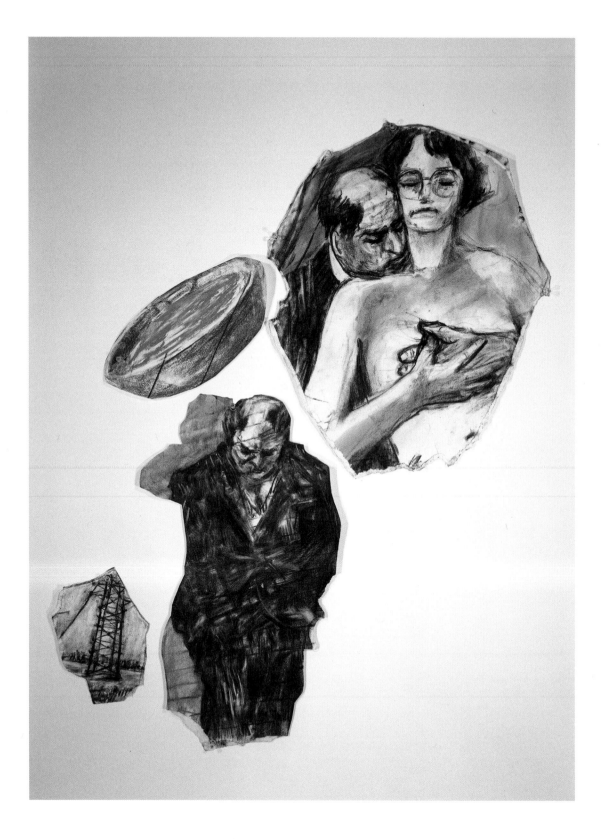

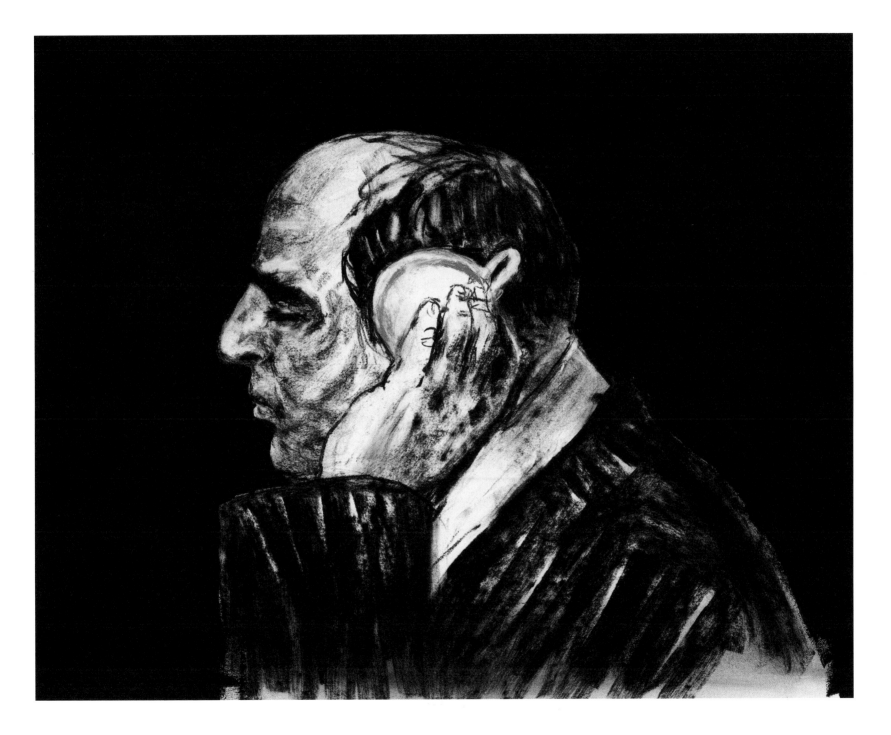

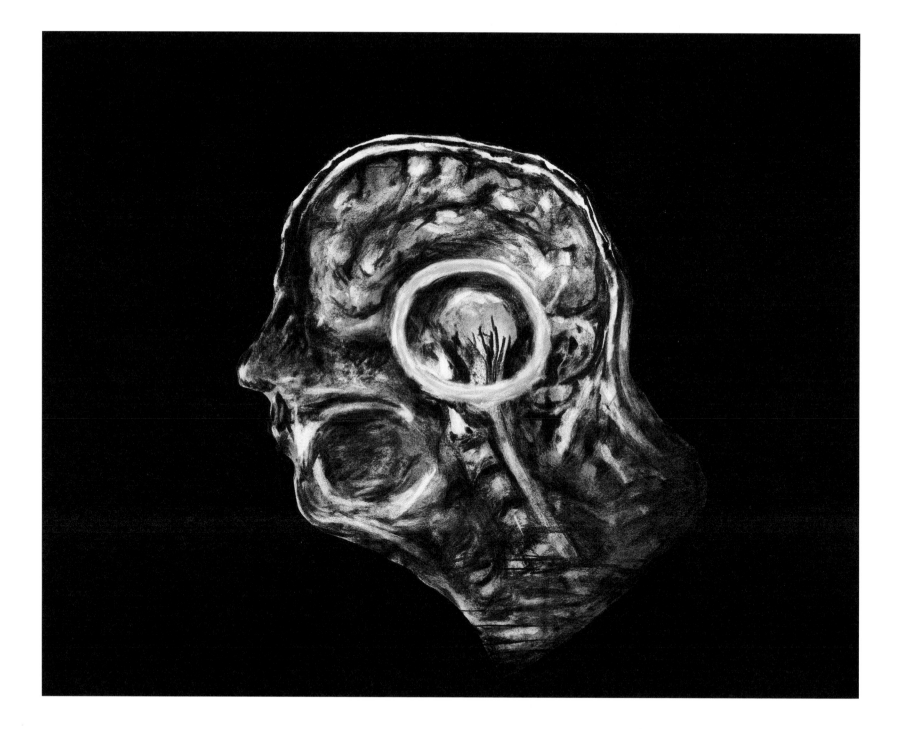

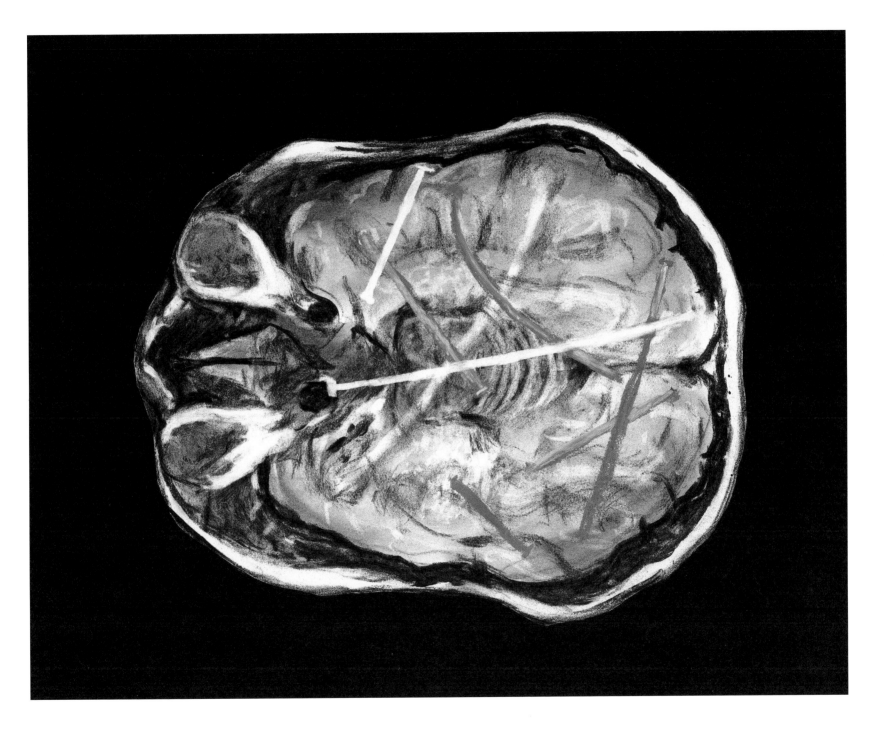

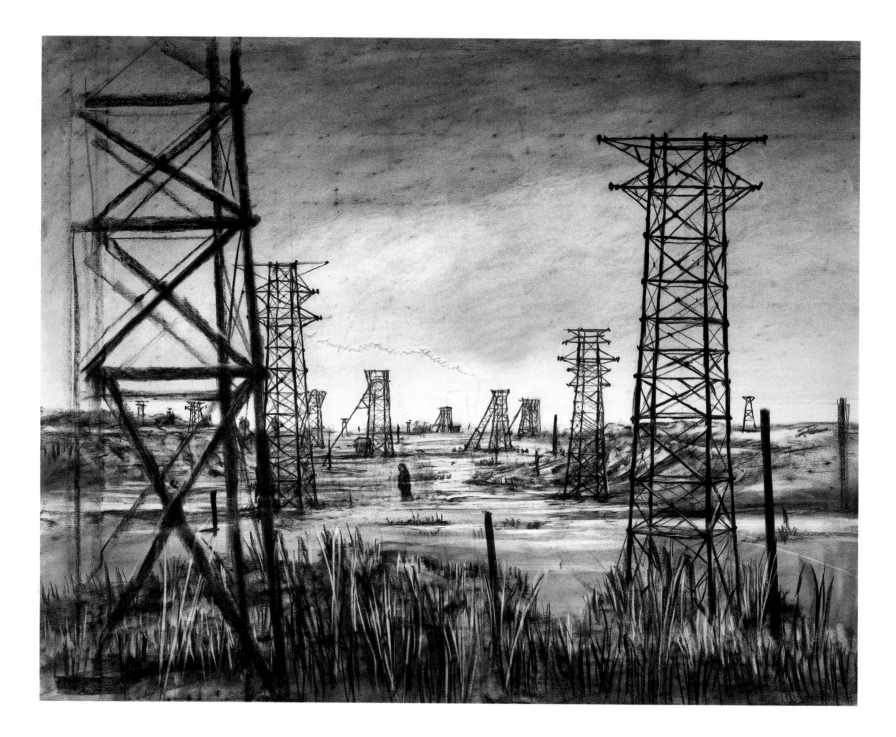

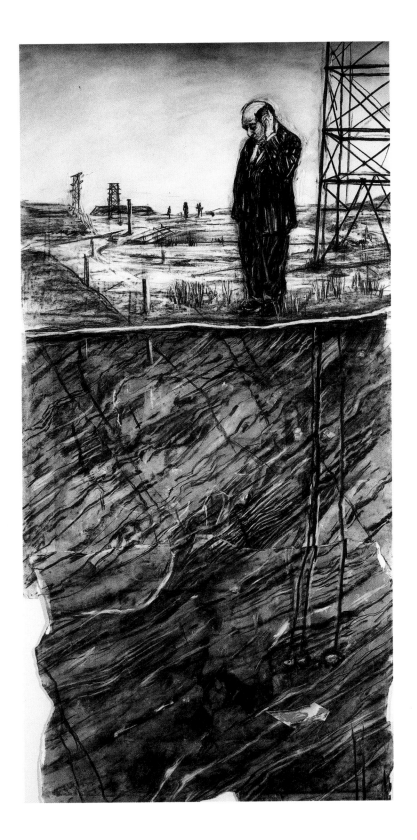

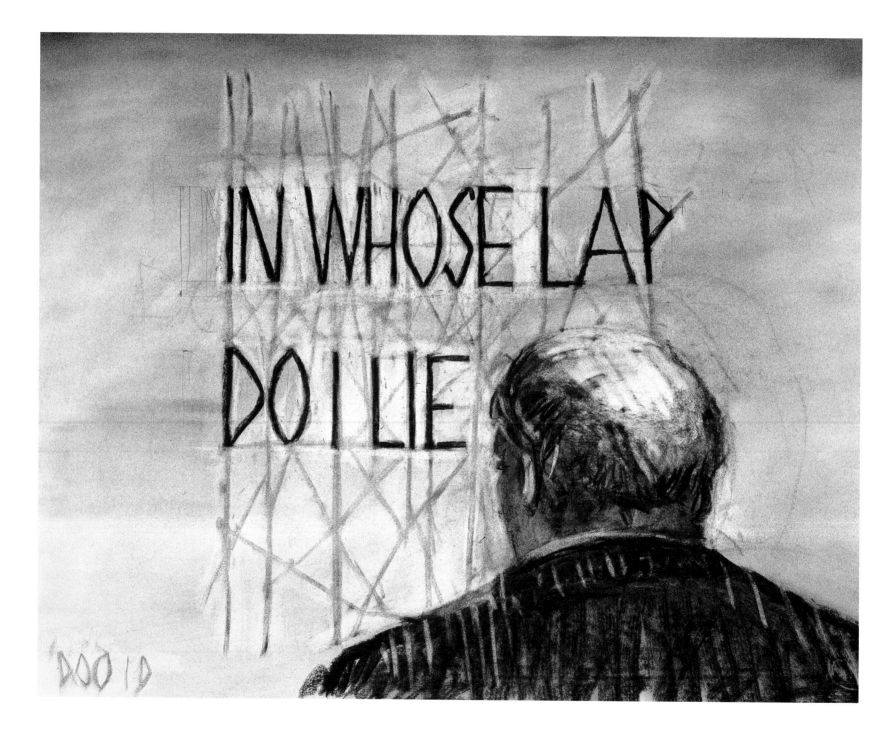

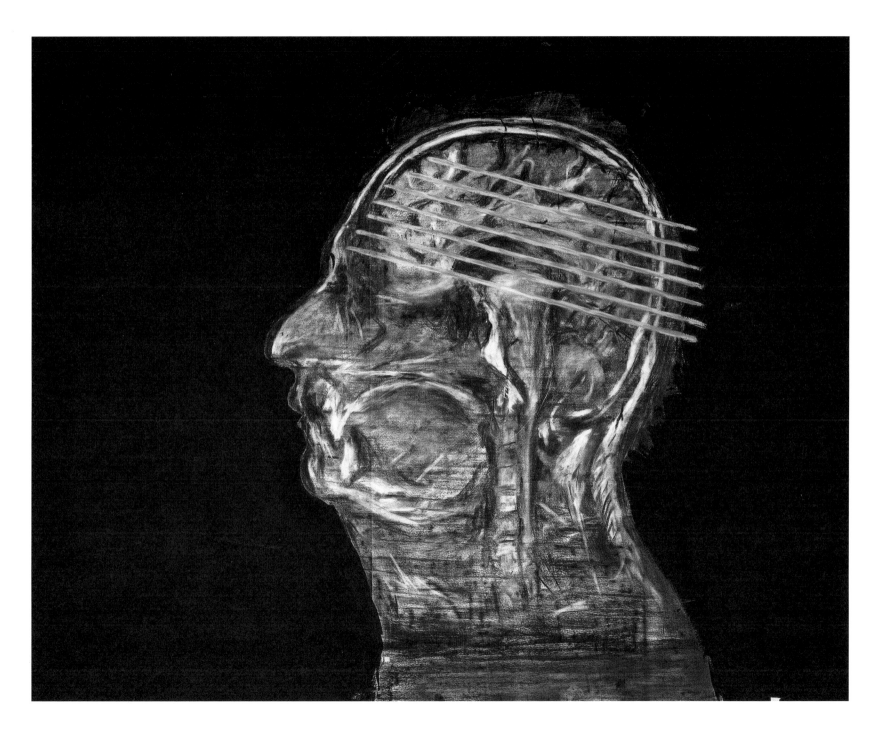

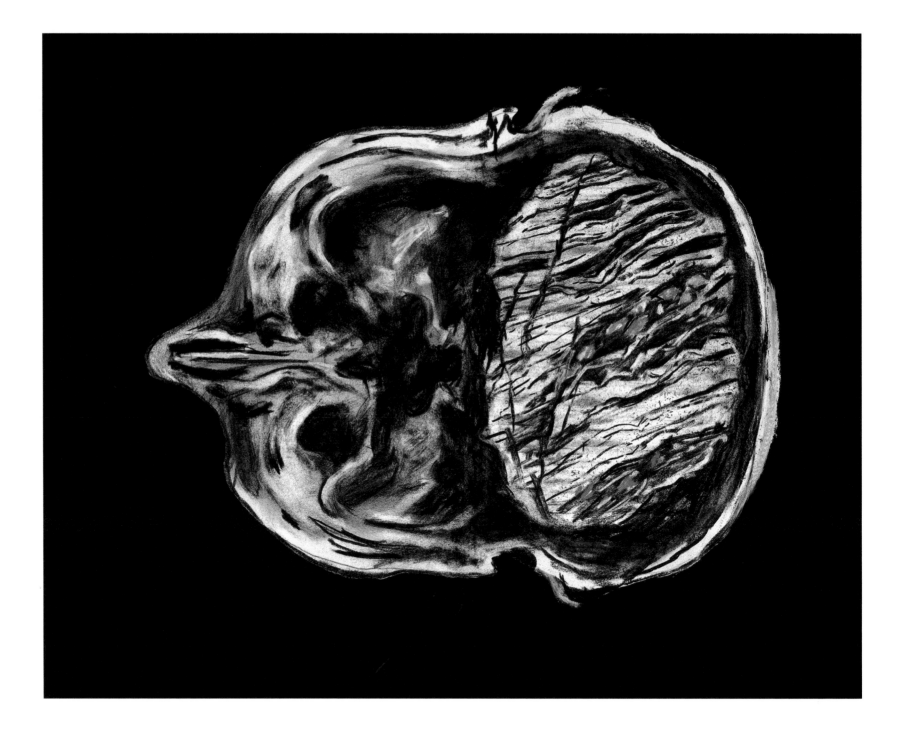

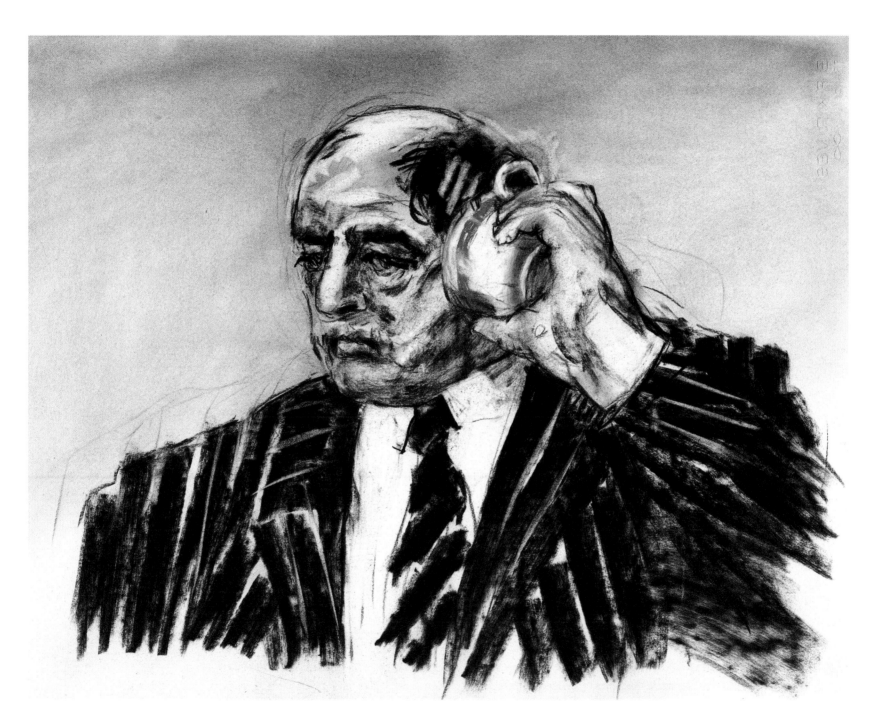

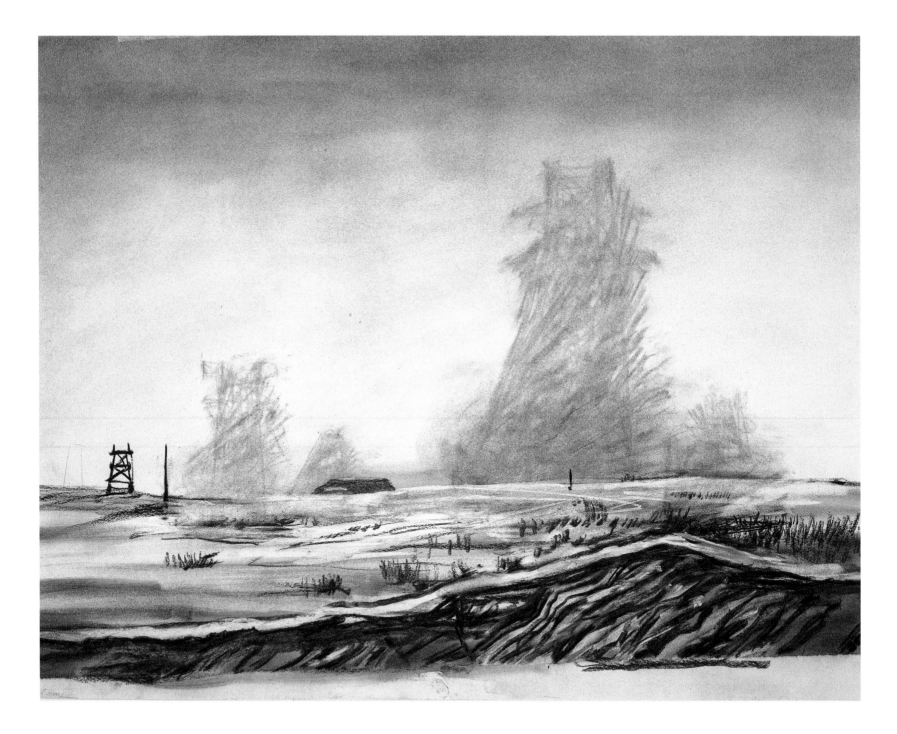

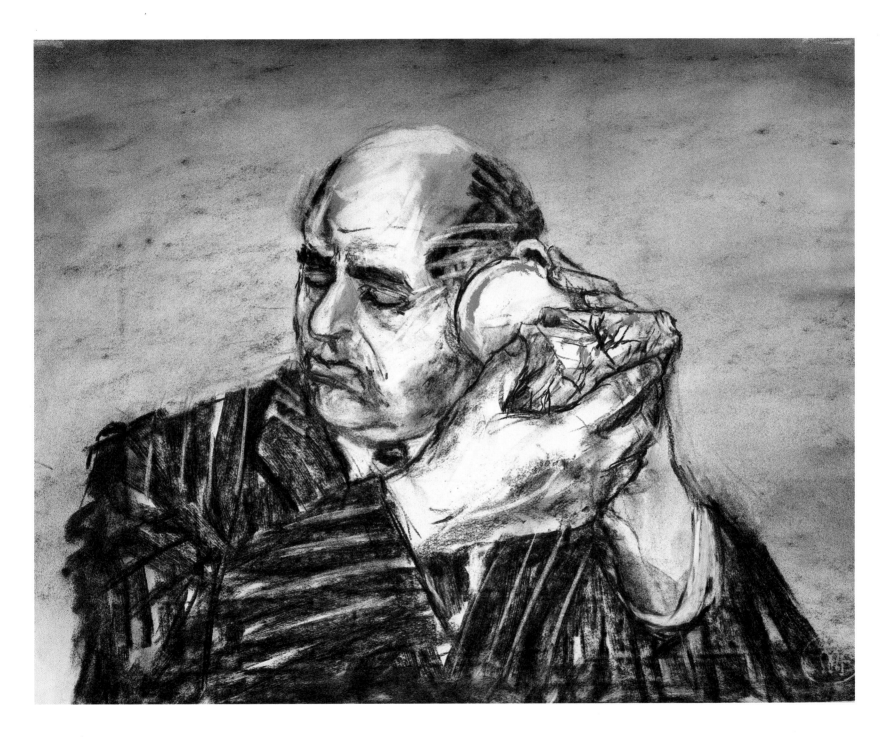

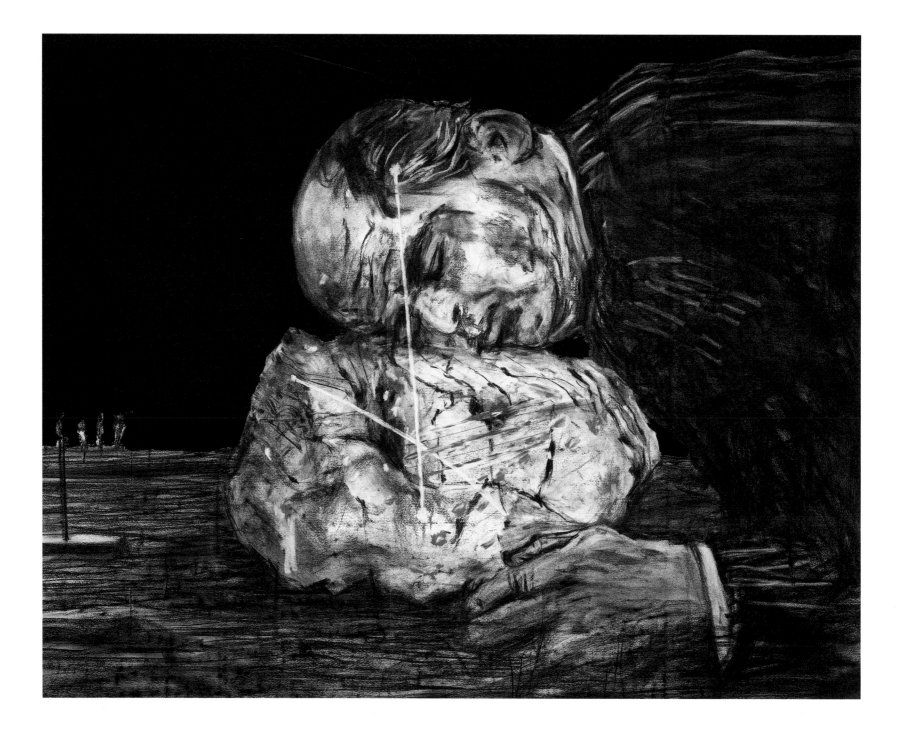

 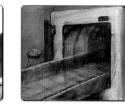 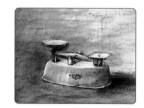

Checklist

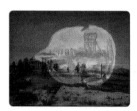 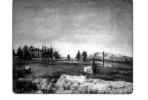 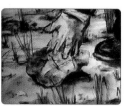 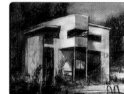 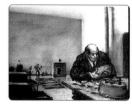 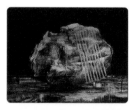

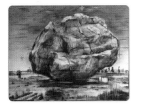 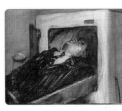 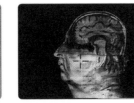 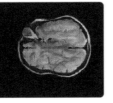 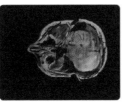

Exhibition History

William Kentridge

Born 1955, Johannesburg, South Africa
Lives and works in Johannesburg

1973-76 University of Witwatersrand, Johannesburg

1976-78 Johannesburg Art Foundation

1981-82 École Jacques LeCoq, Paris

SELECTED SOLO EXHIBITIONS

1979

William Kentridge, Market Gallery, Johannesburg

1981

Domestic Scenes, Market Gallery, Johannesburg

1985

William Kentridge, Cassirer Fine Art, Johannesburg

1986

William Kentridge, Cassirer Fine Art, Johannesburg

South African Arts Association, Pretoria

1987

In the Heart of the Beast, Vanessa Devereux Gallery, London

Standard Bank Young Artist Award, Grahamstown Festival; traveled to Tatham Art Gallery, Pietermaritzburg; University Art Galleries, University of Witwatersrand, Johannesburg; University Art Gallery, University of South Africa, Pretoria; Durban Art Gallery, South Africa (catalogue)

1988

William Kentridge, Cassirer Fine Art, Johannesburg

1989

Responsible Hedonism, Vanessa Devereux Gallery, London

1990

William Kentridge: Drawings and Graphics, Cassirer Fine Art, Johannesburg, and Market Gallery, Johannesburg

William Kentridge: Drawings, Gallery International, Cape Town

1992

William Kentridge: Drawings for Projection, Goodman Gallery, Johannesburg; traveled to Vanessa Devereux Gallery, London (catalogue)

1993

Ruth Bloom Gallery, Santa Monica

1994

Felix in Exile, Goodman Gallery, Johannesburg

1996

Eidophusikon, Annandale Gallery, Sydney

Residency, Civitella Ranieri Center, Umbertide, Italy

1997

Applied Drawings, Goodman Gallery, Johannesburg

1998

William Kentridge, The Drawing Center, New York

Residency, Museum of Contemporary Art, San Diego

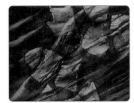 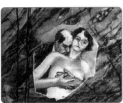 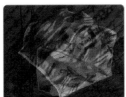 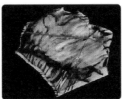 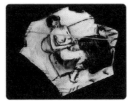 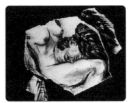

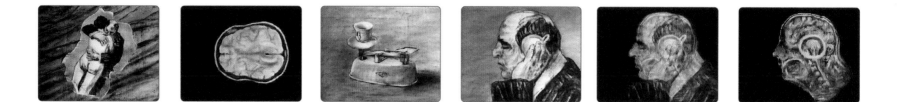

Exhibition History continued

WEIGHING...and WANTING, Museum of Contemporary Art, San Diego; traveled to North Dakota Museum of Art, Grand Forks; MIT List Visual Arts Center, Cambridge, Massachusetts; Forum for Contemporary Art, St. Louis, Missouri; Salina Art Center, Salina, Kansas; Art Gallery of Ontario, Toronto; University of Michigan Museum of Art, Ann Arbor; Bowdoin College Museum of Art, Brunswick, Maine (catalogue)

William Kentridge, Stephen Friedman Gallery, London, and A22 Gallery, London

William Kentridge: New Editions, Cindy Bordeau Fine Art, Chicago

William Kentridge, Palais des Beaux-Arts, Brussels; traveled to Kunstverein, Munich; Museu d'Arte Contemporani de Barcelona; Serpentine Gallery, London; Centre de la Vielle Charité, Marseilles; Neue Galerie Graz, Austria

1999

Ulisse: Echo, Netherlands Architectural Institute, Rotterdam

Projects 68: William Kentridge, The Museum of Modern Art, New York

Sleeping on Glass, Marian Goodman Gallery, Paris

Goodman Gallery, Johannesburg

2000

Marian Goodman Gallery, New York

Annandale Galleries, Sydney

Stephen Friedman Gallery, London

Retrospective of animated films, Internales Trickfilm-Festival, Stuttgart

Retrospective of animated films, New Zealand Film Festival, Wellington

2001

William Kentridge, Hirshhorn Museum and Sculpture Garden, Washington, D.C.; New Museum of Contemporary Art, New York; Museum of Contemporary Art, Chicago; also traveled to Contemporary Arts Museum, Houston, Texas; Los Angeles County Museum of Art, Los Angeles (catalogue)

SELECTED GROUP EXHIBITIONS

1978

Akis 101 Gallery, Johannesburg

1981

National Graphic Show, Association of Art, Belville, Cape Province

1982

American Film Festival, New York

1985

Tributaries, Africana Museum, Johannesburg; traveled to BMW Museum, Stuttgart (catalogue)

Cape Town Triennial, South African National Gallery, Cape Town; traveled to King George VI Art Gallery, Port Elizabeth; University of the Orange Free State Art Gallery, Bloemfontein; William Humphrey Art Gallery, Kimberly; Tatham Art Gallery, Pietermaritzburg; Durban Art Gallery; Johannesburg Art Gallery; Pretoria Art Museum (catalogue)

Eleven Figurative Artists, Market Gallery, Johannesburg

Paperworks Exhibition, Natal Arts Society, Durban

American Film Festival, New York

London Film Festival, London

1986

New Visions, Market Gallery, Johannesburg

Claes Eklundh, William Kentridge, Thomas Lawson, Simon/Neuman Galleries, New York

But, this is the Reality, Market Gallery, Johannesburg

Durban Film Festival, Durban

Cape Town Film Festival, Cape Town

1987

Three Hogarth Satires: Robert Hodgins, William Kentridge, Deborah Bell, University Art Galleries, University of Witwatersrand, Johannesburg (catalogue)

Hogarth in Johannesburg: Robert Hodgins, William Kentridge and Deborah Bell, Cassirer Fine Art, Johannesburg

1988

William Kentridge and Simon Stone, Gallery International, Cape Town

1989

South African Landscapes, Everard Read Gallery, Johannesburg

African Encounters, Dome Gallery, Brooklyn, New York

1990

Art from South Africa, organized in association with the Zabalaza Festival, London; Museum of Modern Art, Oxford; traveled to Mead Gallery, University of Warwick; Aberdeen City Art Gallery; Royal Festival Hall, London; Bolton Art Gallery; City Museum and Art Gallery, Stoke-on-Trent; Angel Row, Nottingham (catalogue)

1991

Five Gouache Collage Heads, Newtown Gallery, Johannesburg

Gala, Association of Art, Bellville, Cape Province

Little Morals (with Deborah Bell and Robert Hodgins), Taking Liberties Gallery, Durban

1993

Easing the Passing (of the Hours) (with Robert Hodgins and Deborah Bell), Goodman Gallery, Johannesburg; traveled to Johannes Stegmann-Kunstgalery, University of the Orange Free State; Art Gallery, Bloemfontein, South Africa

Incroci del Sud: Affinities—Contemporary South African Art, XLV Venice Biennale; traveled to Sala 1, Rome; Stedelijk Museum, Amsterdam (catalogue)

Edinburgh International Film Festival, Edinburgh

Annecy International Festival of Animated Film, Annecy

Best of Annecy, The Museum of Modern Art, New York; Musée National d'Art moderne, Centre Georges Pompidou, Paris

1994

Trackings: History as Memory, Document & Object, New Work by Four South African Artists, Art First, London

Goodman in Grahamstown, Victoria Primary School, Grahamstown

Displacements, Mary and Leigh Block Museum of Art, Northwestern University, Evanston, Illinois

David Krut Editions, Spacex Gallery, Exeter

1995

Africus (with Doris Bloom), 1st Johannesburg Biennial (catalogue)

Memory and Geography (with Doris Bloom), Galeria Stefania Miscetti, Rome (catalogue)

Mayibuye I Afrika: 8 South African Artists, Bernard Jacobson Gallery, London

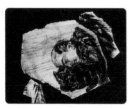
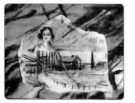
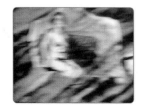
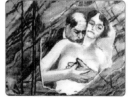
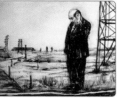
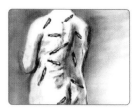

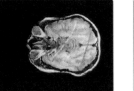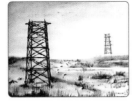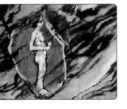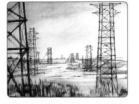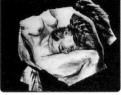

Panoramas of Passage: Changing Landscapes of South Africa, Albany Museum, Grahamstown; traveled to Meridian International Center, Washington, D.C.; African American Museum, Dallas; Fernbank Museum of Natural History, Atlanta; Harriet and Charles Luckman Gallery, California State University, Los Angeles; The Joseloff Gallery, University of Hartford, West Hartford; National Museum of Afro-American Culture, Wilberforce; The Arkansas Arts Center, Little Rock; Flint Institute of Art; University of Kentucky Museum, Lexington; Gertrude Posel Gallery, University of Witwatersrand, Johannesburg

On the Road—Works by 10 Southern African Artists, organized by Africa 95, London; Delfina Studio Trust, London (catalogue)

Eidophusikon, 4th Istanbul Biennial (catalogue)

Annecy International Film Festival, Annecy

1996

Common and Uncommon Ground: South African Art to Atlanta, City Gallery East, Atlanta (catalogue)

Colours: Kunst aus Sudafrica, Haus der Kulturen der Welt, Berlin (catalogue)

Simunye: We Are One. Ten South African Artists, organized in association with the Goodman Gallery, Johannesburg, Adelson Galleries, New York

Faultlines: Inquiries into Truth & Reconciliation, The Castle, Cape Town

Jurassic Technologies Revenant, 10th Sydney Biennale (catalogue)

Inklusion/Exklusion, Reininghaus, Graz, Austria (catalogue)

Don't Mess with Mr. In-between: 15 artistas da África do Sul, Culturgest, Lisbon (catalogue)

Camp 6: The Spiral Village, Galleria Civica d'Arte Moderna e Contemporanea, Turin; traveled to Bonnefanten Museum, Maastricht (catalogue)

Festivals des Dessins Animés Le Botanique, Brussels

1997

Contemporary Art from South Africa, organized by Riksutstillinger, Oslo; Stenersenmuseet, Oslo (catalogue)

Città Natura, Palazzo delle Esposizioni, Villa Mazzanti, Rome (catalogue)

Cram, Association of Visual Arts, Cape Town (catalogue)

El individuo y su memoria, VI Bienal de la Habana, Havana (catalogue)

Documenta X, Kassel, Germany (catalogue)

Lift-Off, Goodman Gallery, Johannesburg

Ubu: ±101 (with Robert Hodgins and Deborah Bell), organized by National Festival of the Arts, Grahamstown, Observatory Museum, Grahamstown; traveled to Gertrude Posel Gallery, University of Witwatersrand, Johannesburg (catalogue)

Truce: Echoes of Art in an Age of Endless Conclusions, SITE Santa Fe, New Mexico (catalogue)

New Art from South Africa, Talbot-Rice Gallery, University of Edinburgh (catalogue)

Fin de Siècle Festival, Galerie Michèle Luneau, Nantes

Collaborations (1987-1997) (with Deborah Bell and Robert Hodgins), Johannesburg Art Gallery

Lifetimes: Kunst aus dem südlichen Afrika, Aktionsforum Praterinsel, Munich (catalogue)

Not Quite Christmas Exhibition, Linda Goodman Gallery, Johannesburg

Delta, ARC Musée d'Art Moderne de la Ville de Paris (catalogue)

Trade Routes: History and Geography, 2nd Johannesburg Biennial (catalogue)

1998

Vertical Time, Barbara Gladstone Gallery, New York

Hugo Boss Prize Exhibition, Solomon R. Guggenheim Museum, SoHo, New York

XXIV Bienal Internacional de São Paulo (catalogue)

Dreams and Clouds, Kulturhuset, Stockholm

Shoot at the Chaos, Spiral/Wacoal Art Centre, Tokyo

FNB Vita Award, Sandton Civic Gallery, Johannesburg

New Acquisitions, Carnegie Museum of Art, Pittsburgh

Unfinished History, Walker Art Center, Minneapolis; traveled to Museum of Contemporary Art, Chicago

1999

Carnegie International 1999/2000, Carnegie Museum of Art, Pittsburgh (catalogue)

A Sangre y Fuego (No Quarter Given), Espai d'Art Contemporani de Castello, Valencia, Spain

La Ville, Le Jardin, La Memoire, Villa Medici, Rome

Kunstwelten im dialog, Museum Ludwig, Cologne

dAPERTutto, Biennale di Venezia, Venice (catalogue)

Rewind/Fast Forward.ZA, Van Reekum Museum, Apeldoorn, The Netherlands

6th Istanbul Biennial (catalogue)

2000

Insistent Memory: The Architecture of Time in Video, Harn Museum of Art, University of Florida, Gainesville

Shanghai Biennial (Shimizu-Toshio), New Shanghai Art Museum, China

Outbound: Passages from the 90's, Contemporary Arts Museum, Houston

Videobrasil, São Paulo

A Double View: Three Exhibitions, Tel Aviv Museum of Art, Tel Aviv, Israel

Kwangju Biennial, Kwangju, Korea

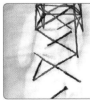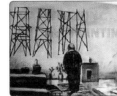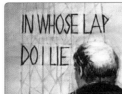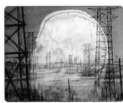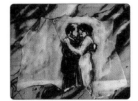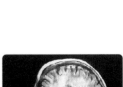

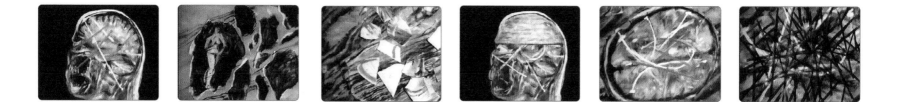

Selected Bibliography

1985

James, Samantha. "Powerful Imagery of Haunted World in Charcoal." *The Star* (Johannesburg), April 26.

Ozinski, Joyce. "William Kentridge's Rich and Expressive Art." *Rand Daily Mail* (Johannesburg), May 3.

Collinge, JoAnne. "Under Fire: As South Africa's Crisis Deepens, Its Independent Filmmakers Document the Pain of Apartheid." *American Film* 11 (November): 30-34.

1986

Powell, Ivor. "Interview with William Kentridge." *Weekly Mail* (Johannesburg), November 7.

Martin, Marilyn. "William Kentridge: Cassirer Fine Art." *Weekly Mail* (Johannesburg), November 7.

James, Samantha. "Talent Sets Trap for Kentridge." *The Star* (Johannesburg), November 14.

1987

Hilliard, Elizabeth. "Vanessa Devereux Gallery." *Arts Review* (London) 39, May 8: 295.

Crump, Alan. "Standard Bank Young Artist Award." *Art Design Architecture* (Cape Town) 4.

Bunn, David and Jane Taylor. "Introduction." *TriQuarterly: South Africa—New Writing, Photographs and Art.* (Evanston, Illinois: Northwestern University; reprinted by Chicago University Press).

1989

Williamson, Sue. *Resistance Art in South Africa.* (Cape Town, Johannesburg: David Philip).

1990

Powell, Ivor. "Kentridge's Free-floating Art of Ambiguities." *Weekly Mail* (Johannesburg), April 26.

Geers, Kendell. "William Kentridge: Cassirer Fine Art and The Gallery on the Market." *The Star Tonight* (Johannesburg), May 9.

1991

Gossler, Horst. "Not Half Crazy." *Sunday Times* (Johannesburg), March 24.

1992

Godby, Michael. "William Kentridge: Four Animated Films." *Revue Noire* (Paris) no. 11 (December/January 1993).

Friedman, Hazel. "Not for the Walls But for the Soul..." *The Star Tonight* (Johannesburg), March 11.

Hall, Charles. "William Kentridge: Vanessa Devereux Gallery." *Arts Review* (London) 44 (June): 224-25.

Accone, Darryl. "Animated Encounters in 3-D." *The Star Tonight* (Johannesburg), September 18.

Blignaut, Charl. "Making Sense of Darkness." *Vrye Weekendblad* (Johannesburg), September 18/24.

1993

Simmons, Rosemary. "Romancing the Plate." *Printmaking Today* (London) 2 no. 4 (Winter).

Tøjner, Poul Erik. "Meeting Place Johannesburg." *Weekendavisen* (Copenhagen) (December).

Berman, Esmé. "What is it?" *Painting in South Africa.* (Pretoria: Southern Book Publishers).

1995

Rosengarten, Ruth. "Inside Out." *frieze* (London) no. 23 (Summer).

Gevisser, Mark. "Empire in all its delirium." *Mail & Guardian Weekly* (Johannesburg), July 21/27.

Hawthorne, Peter. "The Devil You Know." *Time Magazine* (New York), August 14.

1996

Waites, James. "Drawing on an African Experience." *The Sydney Morning Herald* (Sydney), March 27.

Schmitt, Olivier. "Inattendus parfums d'Afrique du Sud." *Le Monde* (Paris), July 13.

Williamson, Sue. "William Kentridge: Devils and Angels." *Art in South Africa: The Future Present.* (Cape Town, Johannesburg: David Philip).

1997

Geers, Kendell. "Kentridge Bridges the Gap." *The Star* (Johannesburg), March 14.

Geers, Kendell. "William Kentridge: Applied Drawings, Goodman Gallery." *The Star Tonight* (Johannesburg), March 21.

Taylor, Roger. "Momento." *World Art* (Melbourne) (May).

Blazwick, Iwona. "Citynature." *Art Monthly* (London) (June).

Atkinson, Brenda. "Kentridge and the Big League." *Mail & Guardian* (Johannesburg), June 13/19.

Tomeruis, Lorenz. "König Ubu's Terror in Afrika." *Welt am Sonntag* (Weimer), June 29.

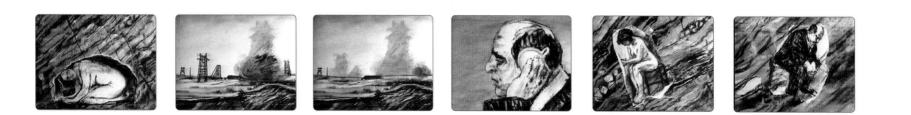

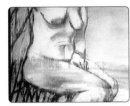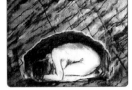

Bédarida, Catherine. "Les anges et les démons sud-africains de William Kentridge." *Le Monde* (Paris), July 1.

McNeil, Donald G., "Theatre Spotlights Horrors of Apartheid." *International Herald Tribune* (Paris), August 6.

Brand, Robert. "Ubu's Exploits Hold a Mirror to SA's Violent Past." *The Star* (Johannesburg), August 8.

Friedman, Hazel. "The Horror..." *Mail & Guardian* (Johannesburg), August 8/14.

Atkinson, Brenda. "Collaborations (1987 - 1997)." *Mail & Guardian* (Johannesburg), August 29.

Geers, Kendell. *Contemporary South African Art, The Gencor Collection.* (Johannesburg: Jonathan Ball).

1998

Curto, A. "William Kentridge." *Juliet* (Trieste, Italy) no. 90 (December/January).

Camhi, Leslie. "Mind Field." *The Village Voice* (New York), January 27.

Holland, Cotter. "Vertical Time." *The New York Times* (New York), January 30.

Pincus, Robert L. "Weighed in the Balance." *San Diego Union Tribune* (San Diego), February 5.

Smith, Roberta. "William Kentridge." *The New York Times* (New York), February 6.

Ollman, Leah. "A Laconic Film—Far from Silent." *Los Angeles Times* (Los Angeles), February 8.

Ferguson, Lorna. "SA Slumbers as Artist Wakes the World." *Sunday Times* (Johannesburg), February 15.

Enwezor, Okwui. "Swords Drawn." *frieze* (London) no. 39 (March/April).

Brooks, Rosetta. "William Kentridge: The Drawing Center/Museum of Contemporary Art, San Diego." *Artforum International* (New York) 36 no. 8 (April): 110.

Hubbard, Sue. "William Kentridge: Stephen Friedman." *Time Out* (London), April 8/15.

Enwezor, Okwui. "Truth and Responsibility: a conversation with William Kentridge." *Parkett* (Zurich) no. 54 (1998/99): 165-76.

Franklin, Sirmans. "William Kentridge: Crowning a Star." *Flash Art* (Milan) no. 200 (May/June): 74-75.

Hauffen, Michael. "William Kentridge: Palais des Beaux Art, Bruxelles; Kunstverein München; Neue Galerie Graz." *Kunstforum International* no. 142 (October/December): 433-34.

Enwezor, Okwui. "William Kentridge." *cream: contemporary art in culture.* (London: Phaidon Press).

Godby, Michael. "William Kentridge's 'History of the Main Complaint — Narrative, Memory, Truth'." *Negotiating the Past: The Making of Memory in South Africa.* (Cape Town: Oxford University Press).

1999

Ollman, Leah. "William Kentridge: Ghosts and Erasures." *Art in America* (New York) 87 no. 1 (January): 70-75.

Barandiaran, Maria-Jose. "William Kentridge: Cindy Bordeau Fine Art; The Art Institute of Chicago." *New Art Examiner* (Chicago) 26 no. 6 (March): 52-53.

Bader, Joerg. "William Kentridge: Macba, Barcelona." *Art Press* (Paris) no. 246 (May): 71-72.

Chambers, Eddie. "The Main Complaint." *Art Monthly* no. 227 (June): 1-4.

Grunberg, Serge. "William Kentridge a Marseille." *Cahiers du Cinema* no. 537 (July/August): 6.

Leonard, Robert. "William Kentridge: Museu d'Art Contemporani de Barcelona." *Art Text* (Los Angeles) no. 66 (August/October): 85-86.

Bouruet-Aubertot, Veronique. "Artiste du mois: William Kentridge." *Beaux Arts Magazine* no. 185 (October): 31.

Sotiriadi, Tina. "William Kentridge: a process of remembering and forgetting." *Third Text* no. 48 (Autumn): 106-8.

Godby, Michael. "William Kentridge: Retrospective." *Art Journal* (New York) 58 no. 3 (Fall): 74-85.

2000

Diserens, C. "William Kentridge: Unwilling Suspensions of Disbelief." *Art Press* (Paris) no. 255 (March): 20-26.

Schwabsky, Barry. "Drawing in Time: Reflections on Animation by Artists." *Art on Paper* (New York) 4 no. 4 (March/April): 36-41.

Krauss, Rosalind. "'The Rock': William Kentridge's Drawings for Projection." *October* (Cambridge, Mass.) no. 92 (Spring): 3-35.

Wright, S. "William Kentridge: l'écran et le trace'." *parachute* (Montreal) no. 98 (April/June): 26-33.

Sheets, Hilarie M. "William Kentridge: Marian Goodman, P.S." *Art News* (New York) 99 no. 8 (September): 170.

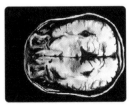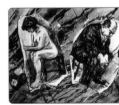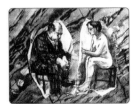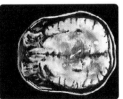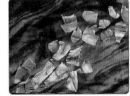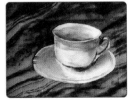

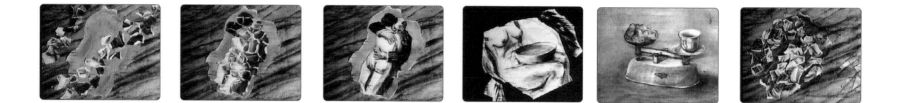

Selected Films and Theater Projects

1978 *Title/Tale*

1981 *Howl at the Moon* (director)

1984 *Salestalk* (writer, director, editor)

1985 *Vetkoek/Fête Galante* (photography, editor, director)

1987 *Exhibition* (writer, photography, director)

1989 *Johannesburg, 2nd Greatest City after Paris* (drawing, photography, director)

1990 *T&I* (photography, director)

1990 *Monument* (drawing, photography, director)

1991 *Mine* (drawing, photography, director)

1991 *Sobriety, Obesity & Growing Old* (drawing, photography, director)

1992 *Woyzeck on the Highveld* (animation, director) Produced by the Handspring Puppet Company

1992 *Easing the Passing (of the Hours)* (computer animation, editor)

1994 *Memo* (drawing, director, photography)

1994 *Felix in Exile* (drawing, photography, director)

1995 *Faustus in Africa!* (animation, director, set design) Produced by the Handspring Puppet Company and Mannie Manim Productions

1996 *History of the Main Complaint* (drawing, photography, director)

1997 *Ubu Tells the Truth* (drawing, photography, director)

1997 *Ubu and the Truth Commission* (director, animation, set designer) Produced by the Handspring Puppet Company, Mannie Manim Productions, Johannesburg, and Art Bureau, Munich

1998 *WEIGHING...and WANTING* (drawing, photography, director)

1998 *Hotel* (drawing, director, photography)

1998 *Il Ritorno d'Ulisse* (director, animation, set design) Produced by the Handspring Puppet Company and La Monnaie/De Munt KunstenFESTIVALdesArts, Wiener Festwochen

1998 *Ulisse: ECHO scan slide bottle* (drawing, photography, director)

1999 *Stereoscope* (drawing, photography, director)

1999 *Sleeping on Glass* (animation, drawing, photography, director)

1999 *Shadow Procession* (animation, drawing, photography, director)

1999 *Overvloed* (animation, drawing, director)

Public Collections

Art Gallery of Western Australia, Perth

The Art Institute of Chicago

Carnegie Museum of Art, Pittsburgh

Durban Art Gallery and Museum

Johannesburg Art Gallery

King George VI Art Gallery, Port Elizabeth, South Africa

Kunstverein, Bremen

Museum of Contemporary Art, San Diego

The Museum of Modern Art, New York

National Gallery of Victoria, Melbourne

National Museum of African Art, Smithsonian Institution, Washington, D.C.

Pretoria Art Museum

The Renaissance Society at the University of Chicago

Roodepoort Museum, Johannesburg

Rupert Art Foundation, Stellenbosch, South Africa

Sandton Civic Gallery, Johannesburg

South African National Gallery, Cape Town

Tate Gallery, London

UNISA Art Gallery, University of South Africa Art Gallery, Pretoria

University of Witwatersrand Art Galleries, Johannesburg

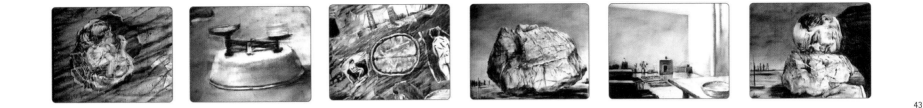

Staff

Administration
Hugh M. Davies, *The David C. Copley Director*
Charles E. Castle, *Deputy Director*
Trulette M. Clayes, *CPA, Controller*
Joyce Corpuz, *Executive Assistant*
Kathlene J. Gusel, *Administrative Assistant*
Michelle Johnson, *Staff Accountant*
Sonia Manoukian, *Administrative/Special Projects Assistant*
Robin Ross, *Accounting/Personnel Clerk*

Curatorial
Elizabeth N. Armstrong, *Senior Curator*
Max Bensuaski, *Assistant Preparator*
Allison Berkeley, *Curatorial Assistant*
Tamara Bloomberg, *Research Assistant**
Allison Cummings, *Registrarial Assistant*
Miki Garcia, *Lila Wallace Curatorial Intern*
Gwendolyn Gómez, *Community Outreach Coordinator*
Mary Johnson, *Registrar*
Toby Kamps, *Curator*
Doriot Negrette Lair, *Curatorial Coordinator*
Kelly McKinley, *Education Curator*
Ame Parsley, *Preparator*
Gabrielle Wyrick-Bridgeford, *Education Programs Assistant*

Development
Anne Farrell, *Director of Development and Special Projects*
Jane Rice, *21st Century Campaign/Major Gifts Director*
Laura Brugman, *Development Assistant*
Kraig Cavanaugh, *Data Entry Clerk**
Michelle Gellner, *Development/Membership Assistant*
Becky McComb, *Membership Coordinator*
Synthia Malina, *Development Manager*
Tamara Wiley, *Corporate Giving Officer*

Events, Visitor Services, Marketing/Public Relations
Jini Bernstein, *Events and Visitor Services Manager*
Jon Burford, *Event Manager*
Laurie Chambliss, *Public Relations/Marketing Assistant*
Pamela Erskine-Loftus, *Museum Events Coordinator*
Sandra Kraus, *Events and Visitor Services Assistant**
Jennifer Morrissey, *Public Relations Officer*
Jana Purdy, *Marketing Manager**
Mike Scheer, *Production Manager*
Event Managers*

Retail Services
Jon Weatherman, *Manager of Retail Services*
Delphine Fitzgerald, *Bookstore Clerk*
Carlos Guillen, *Assistant Bookstore Manager*
Michelle Thomas de Mercado, *Assistant Bookstore Manager*
Bookstore Clerks*

Facilities and Security
Drei Kiel, *Museum Manager*
Mariela Alvarez, *Receptionist, MCA Downtown**
Shawn Fitzgerald, *Site Manager, MCA Downtown*
Tauno Hannula, *Facilities Assistant*
David Lowry, *Chief of Security*
Javier Martinez, *Museum Attendant*
Ken Maloney, *Museum Attendant*
James Patocka, *Facilities Assistant*
Nicholas Ricciardi, *Receptionist/Telecommunications Coordinator*
Demitrio Rubalcabo, *Museum Attendant/Receptionist, MCA Downtown*
Museum Attendants*

*part-time

Board of Trustees

Barbara Arledge
Dr. Mary Bear
Barbara Bloom
Ronald L. Busick
Christopher C. Calkins
Dr. Charles Cochrane
August Colachis
David C. Copley
James DeSilva
Sue K. Edwards
Dr. Peter C. Farrell
Carolyn P. Farris
Pauline Foster
Murray A. Gribin
David Guss
Paul Jacobs
Beatrice Williams Kemp
Mary Keough Lyman
Robert J. Nugent
Mason Phelps
Dr. Carol Randolph
Colette Carson Royston
Nora Sargent
Robert L. Shapiro
J. Anthony Sinclitico
Matthew C. Strauss
Ron Taylor
Gough Thompson
Victor Vilaplana

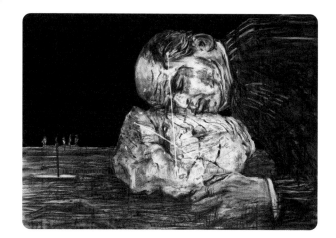